BEAUTY IS CONVULSIVE

BEAUTY IS CONVULSIVE

The Passion of Frida Kahlo

CAROLE MASO

COUNTERPOINT
WASHINGTON, D.C.
NEW YORK, N.Y.

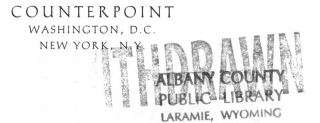

The text includes excerpts reprinted here with the kind permission of the following: *Frida Kahlo: An Open Life* by Raquel Tibol, pp. 13-18, The University of New Mexico Press; "A Genius for Suffering" by Deborah Solomon, *The New York Times;* and, *Frida: A Biography of Frida Kahlo* © 1983 by Hayden Herrera, HarperCollins Publishers Inc.

Library of Congress Cataloging-in-Publication Data

Maso, Carole.
 Beauty is convulsive : the passion of Frida Kahlo / Carole Maso.
 p. cm.
 ISBN 1-58243-089-6
 1. Kahlo, Frida—Poetry. 2. Women painters—Poetry. 3. Women with disabilities—Poetry. 4. Traffic accident victims—Poetry. 5. Women communists—Poetry. 6. Beauty, Personal—Poetry. 7. Mexico—Poetry.
I. Title.
 PS3563.A786 B43 2002
 811'.54—dc21
 2002007470

COUNTERPOINT
387 Park Avenue South
New York, NY 10016

Counterpoint is a member of the Perseus Books Group

10 9 8 7 6 5 4 3 2 1

For Catherine Murphy and Harry Roseman

Votive: Vision

She draws. She draws a door—of breath—breathes on the pane

the glass and draws—a door—an *O* spells polio. Six years old.

She draws. She dreams. Walks with her father again.

River of glass. To the river of—collecting bits of this and that

to examine later under the microscope. To hold. Shells and

plants and stones to draw. All is

votive: vision.

Drawn to the swirling. Live your life.

And her beloved papa photographs her and she adores—

makes love to the lens even then.

Live your life.

Embrace the life you've been given.

Your grave image. Even then. All is

Votive: desire.

And Tina Modotti will photograph you. And Lucienne

Block will photograph you. Edward Weston. Nickolas Muray.

Lola Alvarez Bravo.

And you make love freely to the lens and your life opens

and your life widens like the river. Your grave reflection in the

glass—small boats. And the air makes love to you and the heat.

Listen: the drums. And you leave the frame.

Incessant. Your life—just a girl—opening—

Adore.

She loves the sun clanging and she's drawn. Drawn to the

swirling. The way color keeps coming and going. The way

color. Drawn to the longing.

Her teacher holds an orange and a flame—*imagine*—

vastness—the planets—

She dreams the orange over—solar system—drawn—to

the spinning—She stands in awe.

She draws

Each mark a door.

With her finger in the dirt she makes a three. She dreams. . . .

You are the *alegría* girl, your lucky numbers are 3, 7, 9.

And I am just trying to keep up. She closes her eyes

just a child and touches her dreamy thigh—before—

Before the accident.

Mischievous one. Cheeky. Cheeky one. Climbing trees.

Prankster. Anarchic in the afternoon. Already her dark dares—

her fierce pursuit of pleasure. Her refusal to refuse joy.

Votive: courage.

You are the *alegría* girl ferocious child of fire and I am

standing next to your heat and light—for all these years.

Aura halo aureole

You leave the frame searching looking *Fulang Chang!*

Childish pranks. Monkey business. Monkeys hanging.

Clinging to your neck *Fulang Chang!* you shout. Monkeys

clinging her sexual—

Sunflower, halo, fire. Setting off firecrackers. Throwing

sparklers—light, even then. Hanging from a tree upside down.

The sun clanging monkeys children clinging to her neck and

she's drawn. She calls her monkey, *Fulang Chang!* she shouts.

Irresistible one—taking, asking, begging—looking—look-

ing harder—watching through the window just a child. She

sees her face in the glass. Draws—river of. All is

vision

The sun clanging, *Fulang Chang!* All is light. Drawn to the

way color keeps coming and going. The way color

In the public gardens in the whirling of her—drawn.

Aura, halo Alejandro, dreamboat. Teenage Frida scream-

ing—*Ven, Alejandro,* pink petals—the open fruit—giving up—

soaked, juicy pulp and swoon and seed. Need and lush

Ambrosia. The soft dark nub.

Votive: cup.

Oh you are a curious one.

In a knapsack Frida carried a notebook with drawings,

pinned butterflies and dried flowers, colored pens and philoso-

phy books from her father's library.

And I am writing after her—just trying to keep up.

Elusive—fleeting beautiful one. And I am left again with

everything that escapes the page—

Listen: the judgments. And you leave the frame.

In the margins of her love letters she draws a woman with a

long neck, pointed chin, enormous eyes. *Don't tear her Alejandro*

because she is very pretty—an ideal type.

She draws a cat and laughs. *Another ideal type.*

Ven, Alejandro. Let's peel, let's peel back (24 hours of

incessant drumming on Good Friday) together gently—

watch as I do it—a little bit of skin, my love, my love, just—

oh you are a curious one—a little—to reveal (you tease) and

later to paint. Fruit spread on the earth. Dripping. Fruit now

opened, peeled back beneath an open sky.

See how she—

Free. A little free.

Translucent gleaming.

Sun-drenched

Mischief maker see how she

lit by roses

Incessant dreaming

And she learns to swear. In the square on the days she

skips school. Already her dark dares her pursuit of pleasure

love letters

 Alejandro:

Answer me *Answer me* *Answer me* *Answer me*

 " " " "

 " " " "

 " " " "

Her extracted heart in her hands—her refusal to refuse pain,

posing even then.

 Unstoppable—ribbons of light—set me free—*answer me.*

 And she leaves the frame.

 Answer me.

The girls say they are dying in the formal European. In the

corridor of rules. In the diminutives—in the diminished.

In the regulations. The girls say. Bored with their pedestals.

Their Europe of thorns and decorum. Dark courtyards

and order.

Looking. Looking harder.

Watching through the window the child sees her face

escape—in the glass and follows it. All is vision. Dream.

She draws. Her breath on glass.

The two liked to loiter in the public gardens—drawn—to

the light. Green.

Eye and dream.

Look! Oh look!

Watching him on a scaffold at the Preparatoria. Incessant

painting. Drawn to the debilitating, the promise—drawn to the

fat man Diego Rivera, painting in the air *Creation—can you feel

it*—the way color—shape. *Diego! Diego Rivera!*

Who's there?

She soaps the stairs. And shouting from nowhere, insolent child, *watch out fat man your wife is coming! You'll be caught, face of a dog, face of a frog* (his hundred clandestine affairs) Just a girl.

My only ambition is to have a child by Diego Rivera, the painter. And I am going to tell him someday.

Frida you are crazy.

Just a girl at the Prepa.

Incessant dreaming: a fat man with a palette

on a scaffold casting

beauty, casting appalling

possibility on her—

childish pranks—to dispel the strangeness.

Her sexual halo even then. *You must have been an angel.* He

mutters from the height.

Heat and light.

And one day she shall marry it.

But for now. And you return to the frame. And posing is like freedom some—sometimes.

Her dreamy teenage dreamboat, Alejandro—who will leave
her—*sorry—loose, promiscuous one.*

Incessant drumming dreaming

Answer me.

Voracious in the afternoon.

The girls say they are dying—incessant dreaming—asked
to conform. In the thorned courtyard—exhausted—by all the
tired forms.

Asked to believe those.

Assume those.

Revere those.

(Draw a blue door)

Preposterous sexual stances of modesty and silence—

A little free, a door. The girls liked to kiss in the shadows. . . .

Smooth and perfect thigh tonight

World tonight

Voracious, irreverent—assume those postures of *I'm sorry*
and silence—curious one, self-indulgent, mischief maker. *Fulang*

Chang! she shouts with glee.

Answer me.

Who's there?

Drawn to the vision.

Partially revealed. Voracious: microscope, lens, window, eye.

The girls say they are in those rooms of judgment and pro-
nouncements, dying. In the hedges. And they leave the frame.

Sparklers. And she draws a blue door. Dips her hands in the

Votive: chalice

The girls liked to—

kiss sometimes and other things

The two girls loved to dance

Her charms and secret numbers—setting off sparklers.
Fetish, altar, free a little—*venga*—Come to me. Blue world,
magenta, red. The way color keeps opening flower chalice.
Just a girl.

Mischief maker . . . drinking tequila like a real mariachi.

The girls say they are.

The two girls loved to loiter in the public gardens of the university district where they would listen to the organ-grinders and chat with truants and newsboys. The two girls loved. And the bells.

Tolling miraculous cup. Sun drenched. She dips her hands.

Beauty is convulsive, as Breton will say. As your friend André Breton will say someday—*or not at all*—

Incessant dreaming *Answer me.*

She is the *alegría* girl—the way beauty keeps coming—the way color vibrates—convulsive—drawn

to the swirling

drawn

to the light.

She is the *alegría* girl—incessant dreaming—sparklers—*come to me*—already on fire.

ACCIDENT

‒‒‒‒

". . . A short while ago, maybe a few days ago,
I was a girl walking in a world of colors, of
clear and tangible shapes. Everything was
mysterious and something was hiding; guess-
ing its nature was a game for me. If you knew
how terrible it is to attain knowledge all of a
sudden—like lightning elucidating the earth!
Now I live on a painful planet, transparent as
ice. It's as if I had learned everything at the
same time, in a matter of seconds. . . ."

Votive: Diego

Nothing is comparable to your hands and nothing is equal to the

green-gold of your eyes. My body fills itself with you for days and

days. You are the mirror of night. The violent light of lightning.

The perfect flame of you.

Smell of oak essence, memo-

ries of walnut, green breath

of ash tree. Horizon and land-

spaces I traced them with a kiss.

Oblivion of words will form

the exact language for

understanding the glances of

our closed eyes.

==You are intangible

and you are all the universe which

I shape into the space of my

room. Your absence springs

trembling in the ticking of the

clock, in the pulse of the light;

you breathe through the mirror. From

you to my hands, I caress

your entire body, and I am with

you for a minute and I am with

myself for a moment. And my

blood is the miracle which

runs in the vessels of the air

from my heart to yours.

My Prince sapo-rana. Idol-mountain. Fountain flower. Child. My

fingertips touch your blood.

ACCIDENT

it is coming. my hand. my red vision.

ACCIDENT

⌒⌒⌒⌒

Red covers the page. And a kind of glitter.

Look.

The visible wings of the misshapen angel.

Votive: Child

Because I wanted you with all my blood but it was not to be—

because I wanted you with everything—little monkey, melon,

swallow—color, color

Heart, I would have given you every color

but it was not to be. . . .

In a 1930 drawing of herself and Rivera, she drew and then
erased a baby Diego, seen as if by X-ray vision inside her stom-
ach: the infant's head is up, his feet are down.

Three more times she shall try to have a child

Frida had all kinds of dolls: old-fashioned ones, cheap Mexi-
can dolls made of rags or of papier-mâché. Chinese dolls are
propped on a shelf near her pillow. Beside her bed is an empty
doll bed where she once kept a favored doll, and three little

dolls are enclosed with her baptism dress in a vitrine in her bedroom. One that she treasured, a boy doll that had been given to her by a *cachucha* (probably Alejandro) shortly after her accident, when she was hospitalized.

Because I wanted

The earth is a grave and the earth is a garden poor child rest there, poor child play there forever. The earth holds the tiny hands, the eyes, the little genitals, rest.

Its birth certificate filled out in elegant scroll *His mother was Frieda Kahlo*

take this sorrow: child

I would give you fistfuls of color
if only
alegría

I would have given you.

Because I wanted you *come to me*

the cupped butterfly, painted black.

The city and bay are overwhelming. What is especially fantastic

is Chinatown. The Chinese are immensely pleasant and never

in my life have I seen such beautiful children as the Chinese

ones. Yes, they are really extraordinary. I would love to steal

one so that you could see for yourself.

The central Frida is armless

the useless umbilicus

darling one: small votive, flickering in the dark—

I weep flowers, I weep song, I bleed

the ballerina was broken

the mute blue testimony. She sits at the end of the bed smoking utterly alone. Beside her a grinning doll—together on a child's bed. Misery without end.

My painting carries within it the message of pain. . . . Painting completed my life. I lost three children. . . . Paintings substituted for all of this. I believe that work is the best thing.

votive: faith

You paint the dead baby, all dressed up with nowhere to go. Poor child, poor Frida. Feet first, the soles of his feet facing us—the milky eyes, the dribble of blood, Christ flagellated on his pillow—poor tiny loser, impossible, the never to be, poor thing. Holding a last gladiola. Dressed up for Paradise.

Begging Dr. Eloesser for a fetus in formaldehyde. *Because I wanted—*

House for birds

Nest for love

The only thing I bought here were two old-fashioned dolls, very beautiful ones. One is blonde with blue eyes, the most wonderful eyes you can imagine. She is dressed as a bride. . . . Both are lovely, even with their heads a little bit loose. Perhaps that is what gives them so much tenderness and charm. For years I wanted to have a doll like that, because someone broke one that I had when I was a child, and I couldn't find it again. So I am very happy having two now. I have a little bed in Mexico, which will be marvelous for the bigger one. Think of two nice Hungarian names to baptize them.

The women pray

Accident: 10 Our Fathers, 10 Hail Marys, 3 Glory Bes.

The limping lacerated Mexican saint

She watched other people's children. Because it was not to be.

Pray for us sinners.

The useless petitions

3 Not to Be's

black umbilicus

paint

an umbilical cord emerges from the placenta—the large red

vein paint

paint

even the moon is weeping

paint

heartbreak

all the bleeding children

ACCIDENT

The doll asleep in the lacquered box.

ACCIDENT

~~~

*¡Que venga: la bailarina! ¡La bailarina!*

The dancing disembodied torso.

# Because I wanted you
# (O Mexico)

On the cracked earth—against mountains—an agitated Mexican sky, her prickly pears—states of ripeness, states of fecund—split, delicious, splotches of blood

O Mexico

She cradles a sugar skull and croons

*Tonight I will get drunk*

*Child of my heart*

*Tomorrow is another day*

*And you will see that I am right. . . .*

And at the Salón México, Frida watching with pleasure the women dancing. The little flask of cognac she carried. Her *coctelitos*

fuck. love.

cradling a sugar skull—

drawn to the swirling she draws

*Muertes en Relajo.* Yes, the dead having a fling. Blood mutilation

and sacrifice, *give the dead a little life. The gringos are so glum!*

*dance, dance!*

leaving a foot at the fetish altar.

She laughs

*O you are broken*

drinking tequila

One cigarette after another

A little song at the people's altar: The revolution is harmony of

form and of color and everything that exists and moves. . . .

Frida and Diego would amuse themselves by drawing *ca-

davres exquis* or singing *corridos.* Although Diego couldn't carry

a tune, he loved to sing, and he took pleasure in listening to

Frida, for she sang with great spirit and could handle the

falsetto breaks in songs like "La Malagueña" beautifully.

O beauty Mexico convulsive

*I am the flower, I am the feather, I am the drum and the mirror of*
*the gods. I am the song. I rain flowers. I rain songs.*

*I am the flower. I weep songs. I weep paint.*

the parrot Bonito outside drinking tequila and beer and
squawking I can't—I can't get over this hangover *¡No se me pasa*
*la cruda!*

swearing

the *alegría* girl with glee

a little dog howling
the *alegría* girl on fire

Accident: *dance! dance!* A pair of red legs severed from their

body and between them a pair of lips.

her theater of the ferocious and absurd

her love of the circus, boxing matches, movies, street theater

And she sings in the glade

*I am a poor little deer that lives in the mountains.*

*Since I am not very tame, I don't come down to drink water during*

*the day.*

*At night little by little, I come to your arms, my love.*

Accident:

Everybody tells me not to lose patience, but they don't know

what being bedridden for three months means to me . . . after

having been a real street wanderer all my life. But what can

one do? At least *la pelona* did not take me away.

Everywhere skeletons hanging from the ceilings and walls and

furniture. Big skeletons clothed in popular dress and little

skeletons in all corners of the bed

arrangements of jewels, glass balls, embroidered costumes,

bells, feathers

and skeletons dancing

*la pelona* dancing

layers of petticoats the hems embroidered by Frida with ribald

Mexican sayings

Her Tehuana dress

hair decorated bows clips combs bougainvillea blossoms

an embroidered blouse and long skirt with a ruffle of cotton

on the hem

long necklaces of gold coins

elaborate headdresses with starched lace pleats

and jewelry—glass beads, pre-Colombian jade, colonial pen-

dant earrings

the elaborate stage of you

She raises a ringed hand

*I am only one cell of the complex revolutionary mechanism of the*

*people for peace and of the new Soviet–Chinese–Czechoslovakian–*

*Polish people who are bound by blood to my own person and to the*

*indigenous peoples of Mexico. Amongst these large multitudes of*

*Asiatic peoples there will always be my own faces—Mexican*

*faces—of dark skin and beautiful form, limitless elegance, also the*

*blacks will be liberated, they are so beautiful and so brave . . .*

and she paints.

# Accident:
# Alejandro

"The electric train with two cars approached the bus slowly. It hit the bus in the middle. Slowly the train pushed the bus. The bus had a strange elasticity. It bent more and more, but for a time it did not break. It was a bus with long benches on either side. I remember that at one moment my knees touched the knees of the person sitting opposite me, I was sitting next to Frida. When the bus reached its maximal flexibility it burst into a thousand pieces, and the train kept moving. It ran over many people.

"I remained under the train. Not Frida. But among the iron rods of the train, the handrail broke and went through Frida from one side to the other at the level of the pelvis. When I was able to stand up I got out from under the train. I had no lesions, only contusions. Naturally the first thing that I did was look for Frida.

"Something strange had happened. Frida was totally nude. The collision had unfastened her clothes. Someone in the bus, probably a house painter, had been carrying a packet of powdered gold. This package broke, and the gold fell all over the bleeding body of Frida. When people saw her they cried, '*¡La bailarina, la bailarina!*' With the gold on her red, bloody body, they thought she was a dancer."

# Votive: Diego

*. . . Upon your form, at my touch the cilia of flowers, the sounds of rivers respond. All the fruits were in the juice of your lips, the blood of the pomegranate. . . . of the mamey and pure pineapple. I pressed you against my breast and the prodigy of your form penetrated through all my blood through the tips of my fingers. Odor of essence of oak, of the memory of walnut, of the green breath of ash.*

*You are present, intangible and you are all the universe that I form in the space of my room. Your absence shoots forth trembling in the sound of the clock, in the pulse of the light; your breath through the mirror. From you to my hands I go over all your body, and I am with you a minute and I am with you a moment, and my blood is the miracle that travels in the veins of the air from my heart to yours.*

She draws

his image on her forehead

their faces forming a single head *Diego.*

*Diego, nothing is comparable to your hands and nothing is equal to the gold-green of your eyes. My body fills with you for days and days. You are the mirror of the night. The violent light of lightning. The dampness of the earth. Your armpit is my refuge. My fingertips touch your blood. All my joy is to feel your life shoot forth from your flower-fountain which mine keeps in order to fill the paths of my nerves which belong to you.*

*spoken and signed with magenta kisses.*

# Gringolandia

"He is enchanted with the factories, the machines, etc., like a child with a new toy. The industrial part of Detroit is really most interesting, the rest is, as in all of the United States, ugly and stupid."

On its letterhead, the Wardwell called itself "the best home address in Detroit." What that meant, the Riveras discovered after a few weeks, was that the hotel did not take Jews. "But Frida and I have Jewish blood!" Diego shouted. "We are going to have to leave! I won't stay here no matter how much you lower the price unless you remove the restriction." Desperate for customers, the management promised to comply and also reduced the rent.

New York:

Apparently the thought that capitalists might do well not to hire an avowed communist to decorate one of the world's truly

great urban complexes did not occur to the young Nelson Rockefeller. *Man at the Crossroads Looking with Hope and High Vision to the Choosing of a New and Better Future.*

When an acquaintance suggested that she buy herself some stylish clothes, Frida briefly gave up her long native skirts for the amusement of wearing chic Manhattan modes—even hats—and twitching her hips along the Manhattan sidewalks in a parody of the confident strut of a Manhattan socialite. She poked fun at everything that struck her as funny, and that was a lot.

*Weekly Sales in Millions!*

Nine months later, after the Riveras had left New York, the mural was chipped off and thrown away. . . . When he re-painted the Rockefeller Center mural in Mexico City's Palace of Fine Arts in 1934, he placed John D. Rockefeller, Sr., among the revelers on the capitalist side of the mural, in close proximity to the syphilis spirochetes that swarm on the propeller.

American drugstores, for example, were a fantasy world. Once when she was passing a pharmacy in a taxi, the word *Pharmaceuticals* written on the outside struck her as so ponderous that she composed a song called *Pharmaceuticals* and much to the driver's mirth, sang it loudly during the remainder of the ride.

She adored department stores, shops in Chinatown, and dime stores. Frida went through dime stores like a tornado. Suddenly she would stop and buy something immediately. She had an extraordinary eye for the genuine and the beautiful. She'd find cheap costume jewelry and she'd make it look fantastic.

In the morning when they read newspapers, Frida would burst into laughter over the little photographs of columnists that accompanied their texts. "Look at those crazy heads!" she would say. "It's not possible. They must be crazy in this country!"

*Weekly Sales in Millions!*

Directly in the middle of a composite image that shows Manhattan as the capital of capitalism as well as the center of poverty and protest in the Depression years hangs Frida's Tehuana costume. *My Dress Hangs There.*

. . . Frida mocks the North American obsession with efficient plumbing and the national preoccupation with competitive sports by setting upon pedestals a monumental toilet and a golden golf trophy. . . . Snaking around the cross in the stained glass window in Trinity Church is a large red S that turns the crucifix into a dollar sign . . . instead of showing Federal Hall's marble steps, Frida has pasted on her canvas a graph showing "Weekly Sales in Millions": in July 1933, big business seemed to be doing fine, but the masses—tiny, swarming figures at the bottom of the painting—were not the beneficiaries.

The garbage overflows with a human heart, a hand.

. . . Also their lifestyle seems most dreadful to me: those fucking *parties* where everything is solved after imbibing a

bunch of aperitifs (they don't even know how to get drunk in a happy way.) . . .

You will reply that you can also live there without aperitifs or parties, but in that case, you can never do anything and it seems to me that the most important thing for everyone in Gringolandia is to have ambition and to become "*somebody*," and frankly, I don't have the least ambition to be anybody.

and she watches—

other people dance—

at the parties the rich have, all day and all night.

and she floats—

missing home.

San Francisco Nov 21, 1930

Lovely papá,

. . . I send you all my affection and a thousand kisses. Your
daughter who adores you

Frieducha         here is a kiss

Write to me

everything you do

and everything that happens to you.

Beautiful Chabela, Tell me how Uncle Panchito, Aunt Lolita and
everybody else is doing.

As soon as I arrive you must make me a bouquet of pulque and
quesadillas made of squash blossoms, because just thinking
about it . . .

turkey mole, chiles and tamales with atole

Don't forget me here

*Weekly Sales in Millions!* she croons.

*Pharmaceuticals!*

The industrial part of Detroit is really most interesting, the rest

is as in all the United States, ugly and stupid.

## Votive: Vision

You watch  you scrutinize  your pain

and

paint it  grief

and

paint it

the consolation of your face.

You watch  you observe  your desire

close up and afar

and

at the same time

you paint

You sanctify your pain

and

paint it

with care

love

with utmost tenderness

you watch and tend it

paint.

the limping line

you write

beautiful faltering

You double yourself

or triple yourself

placed on the various stages of your psyche

floating past now on a sponge     *there you go*

a swooning woman with another woman

loving or with a

monkey curling

or a fetus curled up or

the self—

its thousand consolations.

Resourceful, wouldn't you say? laughing you paint

*Self-Portrait with Thorn Necklace and Hummingbird*

*Self-Portrait with Braid, or with Monkey, or with Cropped Hair*

A series of self-portraits. Self-portrait with pompier. Self-por-

trait with young Arlesian. Self-portrait in red by a fountain.

Self-portrait as lighthouse keeper. Or on the rue Saint Jacques.

What the language gave. What the paint—

drawn to the longing

Each mark a door

Each word a boat

The Chinese yin and yang sign,

a mystical griffin,

and in the upper-right-hand corner

the outlined footprint often found in Mexican codices indicating

the direction of events.

a red pressure

or yellow—a yellow feeling—

*Yellow*—

*color of madness, sickness, fear*

*leaf green: leaves, sadness, science. The*

*whole of Germany is this color.*

you paint:

a skeleton running down the page or a Frida caressed by
paws—*reddish purple—old blood of the prickly pear, the brightest,*
*the oldest, and brown—color of mole, of leaves becoming earth.*
real and imaginary celebrating animals

and the smeared mouth.

Hayden Herrara: she would proceed as if she were painting a
fresco rather than an oil, first drawing the general outlines of her
image in pencil and ink and then, starting in the upper left cor-
ner, working with slow, patient concentration across and from
the top downward, completing each area as she went along.

there, there . . . touch me there
and you add paint tenderly sweetly

touch me—

and she puts a little paint—*there*

something blooms

a ripe fruit

her face

the dark corridors of sensibility

A skull with flowers

*look*

She smiles.

dalliance  grief in the afternoon, love

*navy blue: distance. Also tenderness can be of this blue.*

from the near and far

Blood in the corner now saturating the page

Accident: the landscape is day and night.

obscene

obscene

and the little deer

In Aztec mythology and iconography, the image of the deer
stands for the right foot, and it was this part of Frida's body that
was now full of pain.

you watch

you scrutinize

a human head with antlers      weeping

the heart—

extract it

the pain—

isolate it

paint

the deer in the glade

the way the face separates from

the lace of the costume

the way the face seems to float          on one side

                                         on the other side

detached like that for a moment.

in the dissimulation

or the multiplication

mirrored

She paints with her heart and blood and she is adored and

scorned now for it—disparaged—mocked.

worshipped adored

all the Frida icons. She smiles.

Three concerns impelled her to make art, she told a critic in 1944:
her vivid memory of her own blood flowing during her child-
hood accident, her thoughts about birth, death and the "con-
ducting threads" of life, and the desire to be a mother.

Running through the glade, the deer is pierced by 9 arrows.

She laughs and weeps. She winks through tears. Eyebrows like
hummingbirds—*hummingbirds as magic charms to bring luck in love.*

confront the self one more time and look.

2 of you.
after the accident she always saw herself as two Fridas: one
Frida who was dead and one who was alive.

4 quadrants
earth and sky
day and night

3 times she tried to have a child.

Fruit weeps with you.

The knife through the succulent melon paint.

foregrounded against all that encroaches. Whole

*Diego don't go*

The vegetation tangle of cactus and thrusting flowers

Paint solitude.

the foliage encroaching and night

devotion

Behind the skeleton, in the middle distance, what does she see?

*Like the nail, sinister and threatening. Silky and yellow—yellow*

*for illness and madness—*

She sees

on a scaffold he seduces a line of actresses—her daily

hallucination

*Diego!*

2 Fridas

one dead Frida and                    observer and observed

and one who was alive

how to paint feeling

maroon fruit split open *more madness and mystery*

*heart, heart*

3 days of blood (no child)

*Diego!*

she paints

Even the table is wounded. And the skeleton has a broken

right foot.

Stripped this time of her Tehuana costume

dressed in a man's suit

shorn hair  yellow chair

To be sung: *Look if I loved you it was for your hair. Now that your*

*hair is cropped short I don't love you anymore.*

She sits in a desolate yellow chair alone. *Yellow for—*

*Diego, Diego.*

*Avenida Engaño*

A tree with chopped-off branches, 20 numbered, Diego's affairs.

Deceit Avenue

Ruin

*House for birds*

*Nest for love.*

*All for nothing.*

yellow chair alone.

She paints—

Paint the dress without the woman when you can't find her

When you can't bear it paint—

When you can't bear it anymore

And Diego says, and Diego—he smiles with pride

"Look at her work . . . ascetic and tender, hard as steel and fire

and delicate as a butterfly's wing, adorable as a beautiful smile

and profound and cruel as life's bitterness."

paint:

Bonito

paint sadness

*Papa! Papa!*

Do not flinch. Do not turn away—enter pain. Paint love. What

the water gave you

What the language

pleasure, sadness in the afternoon and death

*greenish yellow: All the phantoms wear suits of this color . . . or at least underclothes.*

The death of my father was something terrible for me. I think that it's owing to this that I became much less well and I grew rather thin again. You remember how handsome he was and how good?

Darling Papa, write to me     here is a kiss

*Self-Portrait with Bonito* shows Frida in a dark blouse, wearing no jewelry or hair ornaments—Bonito who had recently died is perched on her shoulder.

paint:
the recumbent Frida—deep incisions in her back

the seated Frida holding court and corset and scorn.

Their criticisms, gossip, recriminations

in the demeaning, in the mean-spirited

"Unregenerate junkie," apply layers of disdain. "nymphoma-

niac, suicidal, alcoholic, self-dramatizing, narcissist" Easy for

you to say

And she is dying posthumously one more time in their scorn

. . . martyr bordered, *la misericorda.*

*Papa!*

holding the yellow flower that the Aztecs associated with death

and that decorate graves all over Mexico.

Her magic numbers, talismans—to ward off any more

the internal lyrical motives that impelled her

All the things she loved

her characteristic small slow affectionate strokes

*Diego*

She paints on the smoothness of metal—touch, touch and gen-

tly with her meticulous brush

the skin of the fruit, tree, rock, stream

I feel you

all is alive I feel you

the miracle of her touch  with paint

her pain  in paint

Heart, uterus, breasts, spine

longing, longing, she paints

intestines—the valves up close

blood through

trembling

smallest of brushes  like eyelashes on skin

she trembles

every hair stands up

painting fur

the tenderness of her touch

a parrot, a small dog

skin of water, fruit, birds

softness—the velvet curtain

the folds of dress

one foot in oblivion—

*love me a little*

and she feels with her eyes the water all over her

and she paints, the flatness of rock, the texture of feather and tree

the exposed heart

roots, veins

*If you could feel what I feel.*

Drops of mother's milk, drops of blood, the weeping fruit

She feels in her the motion

And I am painting the skin of my body—

my pain

with a small brush

something so dear

with reverence.

a touch like no other

There is no artist in Mexico that can compare with her, he says.

The blood pumping of the heart, the severed valves, hurt,

love. Your blood flows up into the distant mountains and

down into the sea, chasm, the red delta, red river, fluid,

brutal poetry of blood and broken

*green: warm and good light*

*cobalt blue: electricity and purity.*  *Love*

she feels in her the joy, the yellow pulsing *mystery madness*

She feels in her the music, voices, pictures, sings.

drawn to the swirling

vibrant, magnetic, *Diego,* the way color

pulses—

the way—

color comes and goes

She feels in her the *alegría*

She would become happy in front of any beautiful thing.

the way color keeps

the way color has always kept

drawn to the swirling

the way the line redeems

consoles sometimes.

the way—broken

impassive, furious, anguished—

the torso split  paint

without flinching

steel corset

breaking apart

*Diego why?*

ionic column

*answer me.*

a pair of legs severed from their body and between them

a pair of lips.

a blood red ribbon circling her neck now *Diego don't go.*

*Diego*

*Love me a little     I adore you*

the way the ribbon connects—

blood of Mexico

—transcends

because I loved you, wanted you.

promiscuous one,

a monkey tail encircles her neck

and lust is just another adornment (thorn necklace,

hummingbird)

a way of getting there

The monkey Frida naked, laughing. *Fulang Chang!* she cries,

she paints.

*Votive: devotion*

egg, pagan, emblem of creation  she paints

you are rejuvenation, you are spring and resurrection, sanctity

of blood, beating wings as your teeth

As your teeth sink into him and you swear yourself once more

into being.

turbulence of earth, puberty and you are back once more at the

Preparatoria before, before . . .

Accident:

ferocious child of light

the broken eggs, maimed dolls, the figure blindfolded, the torn

bridal canopy

And she smiles and she utters unearthly things and she utters

not in any known language, in stars and pain, pulque she says I

am devouring time and the earth

put it in my eyes now

*votive: vision*

## ACCIDENT

I am not sick. I am broken.

But I am happy as long as I can paint.

# Survivor

1. Between the Curtains (Self-Portrait Dedicated to Trotsky)

2. Fulang Chang and Myself

3. The Square Is Theirs (Four Inhabitants of Mexico)

4. I With My Nurse

5. They Ask for Planes and Only Get Straw Wings

6. I Belong to My Owner

7. My Family (My Grandparents, My Parents and I)

8. The Heart (Memory)

9. My Dress Hangs There

10. What the Water Gave Me

11. Ixcuintle Dog with Me

12. Pitahayas

13. Tunas

14. Food From the Earth

15. Remembrance of an Open Wound

16. The Lost Desire (Henry Ford Hospital)

17. Birth

18. Dressed Up for Paradise

19. She Plays Alone

20. Passionately in Love

21. Burbank—American Fruit Maker

22. Xochitl

23. The Frame

24. Eye

25. Survivor

## ACCIDENT

⁓⁓

I have a cat's luck since I do not

die so easily and that's always something.

# Accident

Written by Dr. Henriette Begun in 1946

**1926:** Accident causes fracture of third and fourth lumbar vertebrae, three fractures of pelvis, eleven fractures of right foot, dislocation of left elbow, penetrating abdominal wound caused by iron handrail entering left hip, exiting through vagina and tearing left lip. Acute peritonitis. Cystitis with catheterization for many days. Three months bed rest at Red Cross hospital. Spinal fracture not recognized by doctors until Dr. Ortiz Tirado ordered immobilization with plaster corset for nine months. After three or four months of corset patient suddenly felt entire right side "as if asleep" for hour or more, this phenomenon giving way with injections and massage; symptoms not repeated. At removal of corset patient resumed "normal" life, but from then on has had sensation of constant fatigue and at times pain in backbone and right leg, which now never leave her.

**1929:** Marriage. Normal sex life. Pregnancy in first year of marriage. Abortion because of malformed pelvis. Wasserman and Kahn (W&K) tests negative. Constant fatigue and weight loss.

**1931:** In San Francisco, California, examined by Dr. Leo Eloesser. Given several tests, W&K among them, these resulting slightly positive. Two months treatment without a cure. No analysis of spinal fluid. In these days pain in right foot worse, atrophy up to thigh in right leg increases considerably, tendons of 2 toes in right foot retracted, making normal walking extremely difficult. Dr. Eloesser diagnoses congenital deformity of the backbone. X-rays show considerable scoliosis and apparent fusion of third and fourth lumbar vertebrae with disappearance of invertebrate meniscus. Small trophic ulcer appears on right foot.

**1932:** In Detroit, Michigan, attended by Dr. Pratt of Henry Ford Hospital for second pregnancy (four months) with spontaneous abortion despite bed rest and various treatments. Trophic ulcer continues to worsen.

**1934:** Third pregnancy. At three months abortion performed by Dr. Zollinger in Mexico. Exploratory laparotomy showed undeveloped ovaries. Appendectomy. First operation on right foot: excision of five phalanges. Extremely slow healing.

**1935:** Second operation on right foot, finding several sesamoids. Healing equally slow. Lasts nearly six months.

**1936:** Third operation on right foot. From that time on: extreme nervousness, fatigue in backbone with alternating periods of improvement.

**1938:** Consults specialists in bones, nerves and skin in New York. Dr. Glusker succeeds in healing trophic ulcer with electrical and other treatments.

**1939:** Paris, France. Renal colobacteriosis with high fever. Continued backbone fatigue. Ingests great quantities of alcohol. At the end of this year has acute pain in backbone. Attended in

Mexico by Dr. Farill, who orders absolute bed rest with twenty kilogram weight to stretch spine. Several specialists visit and all advise Albee operation: Dr. Albee himself advises same by letter. Dr. Marin and Eloesser oppose this. Fungus infection appears on fingers of right hand.

**1940:** Moves to San Francisco, California. Treated by Dr. Eloesser: absolute rest, very nutritious food, no alcohol, electrotherapy, calcium therapy. Slightly better, again lives more or less normal life.

**1941:** Again experiences exhaustion, with continuous weakness in back, violent pain in extremities. Weight loss, debility, menstrual irregularity.

**1944:** These years show significant increase in tiredness, backbone and right-leg pain. Seen by Dr. Zimbron, who orders absolute bed rest, steel corset which at first makes for more comfort but without stopping pain. When corset occasionally

removed, feels lack of support as though unable to support her-self. Complete lack of appetite continues with rapid weight loss. Weakness, nausea; ordered to bed, evening fever. Patient's state continues worsening. Dr. Zimbron repeats analysis and x-ray, lumbar tap with lipoidal injection (third time). Reaches conclusion that she should be given a laminectomy and spinal graft. Eye examination shows papillary hypoplasia.

**1945:** Again made to wear plaster corset. Can be stood for only a few days because of intense pain in backbone and leg. In the three cerebrospinal taps there were lipoidal injections which were not eliminated: caused higher than normal cranial tension, continued pain in back of neck and spinal column, generally dull but stronger during nervous excitement. General state: exhaustion.

**1946:** Dr. Glusker advises patient to go to New York to see Dr. Philip Wilson, surgeon specializing in spinal operations. Leaves for New York in May. Carefully examined by Dr. Wilson and neurology specialists who consider spinal fusion necessary and

urgent. Performed by Dr. Wilson in June this year. Four lumbar vertebrae fused with pelvis graft and fifteen-centimeter long vitalium plate; bed rest for three months. Patient recovers. Advised to wear special steel corset for eight months, lead calm, restful life. Obvious improvement noted for first three months after operation, after which patient cannot follow Dr. Wilson's orders. Then not convalescing in due form, life filled with nervous agitation, little rest. Feels same fatigue as before, aching neck and backbone, debility, weight loss. Macrocytic anemia. Fungus again appears on right hand.

## ACCIDENT

Nevertheless I have the will to do many things

and I have never felt "disappointed by life"

as in Russian novels.

# The Hours Were Broken

## Divorce

"the stitches do not heal over and the wound does not look as if it is closing."

Cut your hair and watch it fall. Into a circle, desolation. The hair, retaliation rage, wear a man's suit your tears are nails, and a lock of hair is falling, falling, between your legs the scissors resting there, the hair which he adored.

Let the scissors enter the body. Let the two Fridas, hair every-

where, hair everywhere liar, *liar, why* hair in the rungs of the—

*yellow for madness or sickness or fear—*

the yellow chair . . . Outside severed rest there.

And she paints in rage and sorrow fury. And she paints some

say the greatest of her paintings *Diego Diego*

*House for birds*
*Nests for love*
*All for nothing*

*I sell it all for nothing*

*Cropped Hair*

Now that you don't love me—

divorce—the legs dancing away from the rest of the body.

She watched other people dance.

There's no escaping the monkey's paw thorny barbaric yawl

her heart is a fountain its severed valves pump *misericorda*

the lacerated Mexican saint,

all the martyred ones.

What the water gave you finally

What the pain

You so far over there now paint. The table is wounded. Its legs

flayed maimed paint. See how Judas's chest and right foot are

bleeding: and the skeleton has a broken right foot. Over, broken

utterly alone, and she paints her death in lavender and the

plants that will sprout on her grave. And that skeleton there

grinning on the canopy of her bed.

votive: oblivion

*Diego, Diego*

*Ven.*

*Come to me*

Bride tonight

She paints herself, friends, companions, nieces, pets. Desperate

no children *Diego no,* not that anything but she paints: on that

desolate soulscape—

The blood red ribbon uniting her and the paint and the pain

and the world in which

She is walking down a dirt road alone

Diego

the heart

the lock

cut          *look if I loved you it was for your hair*

ring

crow feather

swallow

the fetus        floating        in a bottle

The lock of hair, the ring, the song, the hope (, mother) put it

in a box,

the love we had the dreams the child.

one side                    and the other

the ether rising, the smell of formaldehyde

the locket            *Diego*

   *now that your hair is cropped short I do not love you anymore*

the heart—extract it

the pain, isolate it

when it gets too much

Cristina

when it gets too much

the ribbons from her hair

the dreaming head

fevered

put the dream in the box put the fever, put the—*other people*

*dance*—sorrow put the talons—*Bonito*—

in another place.

the image.

And the one you adored

put the crimson in the white box

sparrows in a jar

put the tears  put the river               *Papá*

put the hurt on one side      and the corset (Cristina why?)

the gradual falling apart.

put the empty clothing

because I wanted

you here          your dress over there.

*Diego*          *don't go*

Black in the gaps between leaves shows that the time is night

which to Frida meant the end of life

*Diego*

And you break into two Fridas—one the Frida whom Diego

loves and the other the Frida Diego no longer loves.

Rupture     Forceps     Incision

the motive, Diego, was always you, and if the pain might be

relieved, a little. And to keep you. And the knife, and the sweet

suture, oh it will feel like being alive or—

the autoeroticism of her wounds

the thing that impels patients to want surgery, *love me, love me*

*my frog-prince,*

and the footless, and the headless, the cracked open and

bleeding—not passive, not dying

*don't go out that door*

*—open me*

*And I want desperately . . .*

*open me up*

What do you want desperately?
*Don't go out that door.*

The hours were broken

libidinous she gives herself freely now she takes

Silky and yellow *yellow for illness and madness* the way that hair
might have felt, her hair in your hands, like a real gringa

the succulent root

*Diego*

*Don't go.*

*Hair on fire candle table shirt ablaze—*

Diego gone again María Felix on fire—*stay*

In the sound of the clock as he moves away

frieze:

A line of Diego heads—A row of Diegos—frieze—

don't go.

the Judas of your touch

we are held together by tears

*Numbers, the economy*
*the farce of words*
*nerves are blue.*

*I don't know why—also red,*
*but full of color.*

*Diego, Diego*

We are held together by arrows now.

martyrdom of glass. the great nonsense

# Votive: Oblivion

*votive: Diego*   these are the vows you take

9 arrows

*votive : oblivion*   to kill the pain

In the sound of the clock, in the pulse of the light,

*Diego, Diego.*

In the violence, in the calm *Diego, Diego,*

my child, my light.

A childish thing.

Child of the people

Child of the revolution

Child of brilliance (standing on a scaffold)

But always a child.

Frog kingdom prince.

*Mirror of night.*

Child of the great occultist

Child of cruelty

Her bridled, brotheled humor

*love Diego*

*and love Diego*

demented

covered in gold a metal rod through her pelvis

*and love Diego is just another*

*maiming thing*

another kind of injury

transforming thing.

      Accident:

      the landscape is day and night.

And she remembers when her mouth . . .

She lures men up double staircases to her lair—

as he breaks her heart again *Diego* just to keep up.

Her library of lovers, her Noguchi, her Trotsky, *Diego, Diego.*

Her viva Sandino, her viva Zapata, *Diego, Diego*

for you

All the assassinated ones. And that cinema of poverty.

Singing drunken patriotic songs all night

the theater of their lives.

Diego who never entirely leaves her body

a maiming thing

mountainous thing

passion *retablo*

Accident:

imagine a red plea in the bright light

asking God, one and one last—furious—*answer me*—one and

only one last time—*answer me.*

papier-mâché Judas *Diego no.*

And he breaks her heart again—

*answer me* and again.

And he wants her only to paint

don't break, don't go, *stay*

9 thorns in a cup

arms and glitter flung

imagine she dares—imagine—what lies under these

clothes, broken.

that pleasuring toward paradise

*Diego*

She applies paint to the skin of the canvas:

*I penetrate the sex of the whole earth, its heat embraces me and in*

*my body everything feels like the freshness of tender leaves. . . . At*

*times your presence floats continuously as if wrapping all my being*

*in the anxious wait for morning. And I notice that I am with you. In*

*this moment still full of sensations, my hands are plunged in oranges,*

*and my body feels surrounded by you.*

*My hands are sunk in oranges.*

She remembers when her mouth—pressed to the ear—to the

hum of the paint and the blood:

*don't kiss anyone else*

magenta, dark green, yellow

And she watches him.

| | | |
|---|---|---|
| Hair on fire, hair on fire | paint | *not my sister* |
| liar wild | she paints | *not my sister* |
| wayward: live | | *not you too* |
| | | *Cristina* |

liar

wild life on fire

And she watches him betray her with her sister.

(red covers the page)

Running through the glade, the deer is pierced by

9 arrows

And she opens herself like a fruit to every man

And the women too. Oh yes you are beautiful and Diego

would approve

*My fingertips touch your blood. She draws.*

These are the vows you take.

votive: vision

the stitches do not close over

*Crimson*

*Crimson*

*Crimson*

*Crimson like the blood*

*that runs*

*when they kill*

*a deer.*

Pierced by 9 Cristinas why

And she paints—the dark paw draped over the shoulder, the

small black eyes—there, there, tenderly, there now so tenderly the

way color—the way color has always—the way paint the way—

*Eyes in the hands and a sense of touch in the eyes.*

    *Diego*

    *Kiss me* love me a little longer—standing in front of

this bit of miracle—this little piece of paradise, honesty, beauty,

bliss, lucidity, she paints:

two butterflies in the braid, two flowers laid over the leaf green

(*sadness, science, the whole of Germany is this color*) and the

encroaching foliage—the eyebrows a hummingbird and

around the neck—delicate drops of blood—the hummingbird

hanging from thorns—on the shoulders the black monkey, the

black cat, and the butterflies will be white and the flowers will

be white, a little free and the white of the blouse—the crimson

mouth—and the eyes are certain—and the eyes—both dead

and alive—see far—

    And it comes to her

    And it comes to her in awe.

    *I cannot love Diego for what he is not.*

# Reunion

"... Diego still loses all the letters that reach his hands, and he leaves his papers everywhere ... he gets very cross when one calls him for a meal, he pays compliments to all the pretty girls, and sometimes he makes an ant eye with some of the city girls who arrive unexpectedly, on the pretext of 'showing them' his frescoes, he takes them for a day or two ... to see the different landscapes. ... for a change he no longer fights as he did before with the people who bother him when he is working, his fountain pens go dry, his clock stops and every fifteen days it has to be sent to be fixed, he keeps wearing those huge miner's shoes (he has used the same ones for three years). He gets furious when he loses the keys of the car, and usually they appear in his own pocket, he never exercises and never sunbathes: he writes articles for newspapers that generally cause a terrific uproar, he defends the IV International with cloak and sword, and he is delighted that Trotsky is here. ...

These are more or less the main details.

*. . . As you can observe, I have been painting—which is a lot to say, since I have spent my life loving Diego and being a good-for-nothing with respect to work, but now I continue loving Diego, and what's more I have begun painting monkeys seriously.*

*. . . You can tell Boit that I am behaving very well in the sense that I do not drink as much cognac, tequila, etc. I consider this one more step forward toward the liberation of the . . . oppressed classes. I drank to drown my pain, but the damned pain learned how to swim. . . .*

# O Mexico

And she closes her eyes onto a bed of nails, and she dies back a

little and she watches an armada 11 ships 500 men 32 crossbows,

and she watches from the distance the little conquistador Hernán

Cortés grow slowly monstrous in her sight. The new Spain.

A comet with three heads hangs over the land.

A temple burns to the ground—

The Heart of the One World breaking open

magenta kisses

The new Spain they say.

The new Spain they say O Mexico!

*La Llorona* weeping for her dead children

*La Malinche, La Chingada,* the violated one—

She weeps.

All the violated ones.

See the tubes of fire, magical six-legged beasts O see

A world of betrayal, blood and ruin

As confirmed by the Aztec prophecy

And in her black pupil she holds her ancient world:

Aztec, Toltec, Mayan, Olmec—at her fetish altar

And she goes further—to the *Chichimeca*, dog people originated

from the Place of Cranes—at her fetish altar—and then further—

and she bites down

Fifty thousand years before. Until the end of the fourth ice age

the indigenous people came across the Bering Strait. *Venga*, she

smiles and waves.

Through the Demerol now she greets Tezcatlipoca, *have a drink*,

the god of evil, embodiment of darkness, the smoking mirror.

And Quetzalcoatl, his benevolent reflection, spirit bird, redeemer,

winged eternity of wind, precious twin. *Do you have a light?*

She holds the double burning bird in her mirrored eye. Dark

and light. 2 Fridas, one who is whole and one who is broken.

Not the leg.

She watches Quetzalcoatl on his doomed path now. Drinking

deeply from the cup, who has tasted such sweetness? until he

loses all memory, then self, then—

and when his lovely sister enters

and when his lovely sister enters the bedchamber

he succumbs and succumbs and succumbs again.

Ashamed he knows he cannot stay and builds a raft of snakes.

*Goodbye*. She hears him say in the Year of One Reed I shall

return one day.

Each year the solar calendar leaves five empty days. Days of

waiting. Days in vain. The Toltecs wait. The Aztecs wait. Thou-

sands of years are passing without a sign of him. Frida laughs.

*Look, now, on the horizon, is it you, can it really be you returned?*

*It's you* she cackles drugged and babbling. In a year of One

Reed: 1519.

*Lord Quetzalcoatl*, Moctezuma bows to him. *Beloved one. How*

*long we've waited.* But it is the one deranged by gold-lust who

takes his hand.

Carrying tubes of fire, the six-legged beast comes, carrying

smallpox, sorrow.

Cortés.

And where there were once villages of mud and clay, flying but-
tresses. At the heart of the One World all the temples, pyramids
destroyed. She closes her eyes to the ruins still.

Now flying buttresses.

The arrogance of their touch.

The Spanish army had so overloaded their horses with gold
and treasure that hundreds were drowned as they crossed
Lake Texcoco.

The arrogance of their touch—Ferdinand, Isabella, Santa Anna,
Cortés. Blood and blood and greed and ruin.

And the French.

My dog people: *heart, heart.* The hundred lamentations. Father
Hildago dreaming liberation . . .

All the tyrants loss and blood and sorrow. *Cinco de Mayo.*

Napoleón. Porfirio Diáz.

And Frida, "daughter of *la raza*," sings a revolution song.

Drinking tequila like a real mariachi. 1913.

*Tonight I will get drunk*

*Child of my heart*

*Tomorrow is another day*

*And you will see that I am right.*

The sun clanging.

She breathes on the glass. She draws an 0

She dreams, and dies a little

*Mexico!*

# Votive: Devotion

*. . . No words can describe Diego's immense tenderness toward the things that possess beauty, his affection for beings who do not have anything to do with the current classless society, or his respect for those oppressed by it. He especially cares about the Indians to whom he is linked by blood; he loves them dearly because of their elegance, beauty and for being the living flower of the cultural tradition of America. He loves children, all animals—especially bold Mexican dogs—birds, plants and rocks. He loves all beings without being docile or neutral. He is very affectionate but he never gives himself completely; for this reason, and because he hardly has time to dedicate to personal relations, they call him ungrateful. He is respectful and refined. . . .*

*. . . He is not sentimental but he is intensely emotional and passionate. Inertia exasperates him because he is a continued, live and potent flow. Because of his extraordinary good taste, he appreciates all that contains beauty, be it a woman or a mountain. . . . Like the cacti of his land, he grows strong and amazing either in sand or on rocks; he blossoms in a lively red, the most transparent white, and*

*sunlike yellow. Covered by thorns, he protects his tenderness inside.*

*He lives with his strong sap in a ferocious environment. He shines*

*alone like a sun avenging the gray color of rocks. His roots go beyond*

*the anguish of solitude and sadness and of all the frailties that domi-*

*nate other beings. He stands up with amazing power, then blossoms*

*and bears fruit like no other plant.*

(And when she is sick he will distract her by dancing
around the bed with a tambourine pretending to be a bear.)

# Disintegration

Awakening on black slap

Awakening on black slap paint (no new pain though, take.

*Take*

Take what?

                              *the pigeon made mistakes*

toe by toe by toe—take

*night*

*votive: courage*

                              *not the leg*

the blackened toes—then take

*night is falling.*

black                         *not the leg*

black                         black toes

black

*night is falling in my life.*    *not the leg*

Ringing

the amputation  3 free let me—

*let me*

3 7 9 *live*

Did the bells not mean she might be saved might—*not the leg*—

be saved

Take the toes then

Bargaining in someone's religion—a made-up thing

3 7 9

the little girl's stash of butterflies, marbles, paints, charms

these are the games she—*not the leg not the*—

these are the games let's play awhile

chattering, counting, babbling

while she drags out her headless dolls her perverse tell all her

bartering her *not the leg*—and the paintings—

pain arranged laid bare

poised like that

*look, look*

Frida what?

Frida what is it?

*Over there.*

drawn to the vision

her head in a sunflower—engulfed by that flame. Her head.

Frida.

she wiggles her—

toes, toes then take

*adiós, mi amigos, adiós*

*not the leg.*

Dr. Farill recommended that her foot be amputated, leaving

only the heel.

Dr. Glusker brought a Doctor Puig, a Catalán bone surgeon

educated in the U.S.

her lucky numbers are—

adiós

begging

she'll be begging—

not the leg.

in pieces

take all the toes at once.

*anything but—*

*You know Frida that I think it is useless to just cut your toes . . .*

*because of the gangrene.*

*I think Frida, the moment has come when it would be better to*

not the—not the—not the

*cut off your leg.*

not old not over not ready to go

*You know Frida that I think that it is useless.*

*you stole from me fourteen beds, fourteen machine guns and four-*

*teen of everything. He only left me his pen, he even stole the lamp,*

*he stole everything.*

Blood in the corner now saturating the page.

Covered in gold where does your life

A metal rod through the pelvis

But not the leg

*You know Frida that I think it is—*

*Cracked pelvis—useless—you know—*

*Not the leg*

*You know Frida*

*Points of support*

On my whole body there is only *one*; and I want two. In order to

have two they have to cut *one*. It is the *one* that I do not have that

I have to have in order to be able to walk, the other will already

be dead!

Raquel Tibol:

Irritated by the vital energy that radiated from an object that she

had created, an energy that she, in her own movements, no longer

possessed, she took a knife made in Michoacán which had a

straight and cutting edge, and overcoming the lassitude produced

by her nocturnal injections, with tears in her eyes, and a convul-

sive grin on her tremulous lips, she began to scratch the painting

slowly, too slowly. The noise of steel against very dry oil paint

grew like a lament in the morning in this space of Coyoacán

where she had been born. . . . She scratched, annihilating,

destroying herself; it was her sacrifice and her expiation.

Your tears are nails

*the pigeon made mistakes*
*it made mistakes.*

*Instead of going North it went South*

*It thought the wheat was water*

*It made mistakes.*

*not the leg*

the sun and the moon out together indicating the sorrow of all

creation

her head is fire

one stiff, paper-doll-like arm. The central Frida is armless. One

bandaged foot . . .

not old, not over, not ready to go.

*the leg*

In the night the bone men come and in the day.

enclosed in a steel corset for eight months.

*the leg*

Like a lament in the morning.

Dr. Eloesser mentions that Frida had been painting up to three months prior to his visit, that she has headaches, and that for a period of time she had had a continuous fever. Her leg, he said, was in constant pain. The rest is illegible except for the word "gangrene."

Votive: oblivion. She swerves.

*Leaves. Blades. cupboards, sparrow*
*I sell it all for nothing. I do not believe*
*in illusion. You smoke terrible.*
*smoke. Marx. life. the great*
*joker. nothing has a name.*
*I don't look at shapes. the paper*

*love. wars. tangled hair. pitchers.*

*claws. submerged spiders. lives*

*in alcohol. children are the days and*

*here it is stopped.*

Her sister Matilde:

They fused three vertebrae with a bone of I don't know who

and the first eleven days were something terrifying for her.

They gave her Chloromycetin every four hours and her temper-

ature began to drop a little but that's the way it has been since

the 4th of April when they operated for a second time and now

the corset is dirty as a pigsty since she is secreting through her

bag, it smells like a dead dog and these *señores* say that the

wound is not closing and the poor child is their victim.

the desperately festive falling apart Frida

All dressed up with nowhere to go

*I sell everything for nothing. . . . I do not believe in illusion . . . the*

*great vacillator. Nothing has a name. I do not look at forms . . .*

*drowned spiders. Lives in alcohol. Children are the days and here is*

*where I end.*

your head is flowers, your body the body of a deer, pierced

Without Hope, she scrapes. *it is coming*

4 black toes

*it is coming*

# Votive: Sorrow

## Mirror of Night

3, 7 and 9 are your lucky numbers. You put them in a glittering
box. You add a pink ribbon, a drawing, a lock of hair. Black
feather. You are no fool. The end is nearing. You draw a right
foot, right foot, a right foot.

You return now to the women. In the calm violence of your
being, desire. You draw a right foot as you drag yourself across
the page to this final place.

Your tears are nails. You hold them in your mouth. Your
last Calvary. Sorrow.

And hear now the women praying their dark rosary—the tone of the cross, 10 our fathers, 10 hail Marys, the drag and hum of the cross. The wound of the cross. Salt.

A paper halo once—a child's cutout falling useless to the floor. See how she suffers. A halo of paper and pins to keep the disintegrated shoulder bone intact. Visiting the woman held together by paper and pins. What do you know of suffering? she asks. And she is right. Paper dolls holding hands. *Good-bye.*

You clutch your fetus in a bottle laughing snidely. So sweet, so angry, so nasty. Formaldehyde. You are no fool. Singing Mexican drinking songs. Your country gone to broken blood and roses. Forcing the head. *Fuck.* Your hands arranging flowers in the dark. You finger your pendants, charms. Laughing. Imagine fingering—you see—

Forcing the ludicrous death head between your breasts—a sugar skull

Dancing last things, imagine fingering you draw with speed slap paint.

Picture roses awful thorns departures sworn last flowing free

The V

of Viva a dipping up and down and—

*Shatter let me shatter along with you a little*

the plaster cracking

A little free.

In the upper register a frieze of androgynous profiles shedding tears.

From the operating theater looking up you hear voices dying away in the garden. Voices are whispering and you are dying in their formal arrangements of posthumous appraisals—their raves, their dismissals. *Most artists lead unhappy lives, but only one has ever achieved cult status by making her unhappy face the main subject of her work. Frida Kahlo's specialty was suffering, and she adopted it as an artistic theme as confidently as Mondrian claimed the rectangle or Rubens the corpulent nude. The majority of her paintings are self-portraits. If you've seen just one you can guess what awaits you in the others: a dark-haired woman with large eyes, a single run-on eyebrow and an expression any tragic heroine would*

*envy.* Leg falling. Leg breaking. In the agreement. In the consensus, the condescension. Those plaster pedestals. *Leave me be.*

And you play one last time directly into their disdain. Narcissist, drama queen, dabbler, hysteric. Dying posthumously from their potshots: *Rivera was a better artist than his wife, but it's she who is now enshrined as a saint. Her self-portraits sell for the requisite millions, and Madonna, who collects them is planning a movie based on her life. This meeting between the Material Girl and the Mexican Communist might seem a bit surreal, but no more so than the current fashion for producing worshipful books on the artist. The tomes of the past few years include a cookbook of her "fiesta" recipes and a biography for teenage girls that presents the artist as the most exemplary female role model since Florence Nightingale.*

Little girls playing at grownup things. Their disdain. In the diminished, in the belittled. *An astonishingly vapid pornographic fantasy, from the Brown/Columbia professor whose previous labors in this vineyard* (The American Woman in the Chinese Hat, *1994, etc.) have been praised by some as masterly . . . Although the poetic sequences contain striking passages and vivid images, they can't convey*

*a story in any recognizable sense, running the high risk of rapidly com-*
*ing to seem pointless. Unfortunately, they form the whole of the book.*

In the mean-spirited, in the demeaning

Floating: a pair of red legs severed from the body—and be-
tween them a pair of lips.

Hair on fire tiny shrunken Frida heads on fire. Tongues are
lapping. laughing, lapsing last grotesque,

total eclipse on fire. A dancing pair of lips. Insisting insinu-
ating separating now you see—

In one 1951 *Still Life* now lost the flagpole's pointed tip
emerges inside the halved fruit's soft dark interior.

And I am still caught in it, in you again and writing the Frida
études and singing little patriotic songs demented songs, let's hear
one, in the bleak hilarity of the end. Lips lowered. Magenta.

Wayward songs and love—through the condescension—
making a muffled song up.

Parts of her

fall away

a hand

an eye

everything we'll usually need  a mouth  a wing

hair on fire

look over there

It's like floating

Your hands arranging . . .

The visible wing of the misshapen angel.

*Pulque*—a kind of ambrosia,

*Sing me into the end* she begs.

Black rose of blood flowering in the eye

Crow feathers glittering in the corners of the room.

Monkey fur.

Where does your life go?

You put it in a box. Marked 3 7 9. Fingering the necklace of

humming birds and thorns

    dark corridor.

    down the dark hall

to the crematorium.

*I am the disintegration* you scrawl you scratch paw—The

noise of steel against skin—*Are you leaving then?*

*No.*

Another shot of Demerol

*Votive: oblivion*

*So touch me with* your disembodied hand. It will be like

floating, it will be like living some.

How badly do you want it?

—other side.

carrying a wooden box.

Men in black ascend double staircases carrying the wooden

box but you are out watching the solar eclipse.

You are out singing off-color songs in front of a falling

curtain of velvet and pulque and blood. The furious theater of

you. "*Diego please make her stop. The operatic pitch of Kahlo's*

*sentiments left little room for the day-to-day particulars of experi-*

*ence. Her diary provides neither startling disclosures nor the sort*

*of mundane, kitchen-sink detail that captivates by virtue of its*

*ordinariness. . . . Kahlo's diary allows for no such dreamy*

*identification with its subject, whose life was less lived than*

*staged."* Deborah Solomon "reviewing" your diary in the *New*

*York Times* would like to insult you a little longer

But you are out painting solitude.

drawing a right foot.

drawing

hair on fire. Shaking your fetus in a bottle.

remembering . . .

Frida adored children. She believed they possessed purer

creative powers than adults.

The tone of the box 10 our fathers—

the hum of the box.

—are ascending double staircases with roses and weeping.

10 our fathers

hope

But they are in another corner of the dark garden altogether

force-feeding each other flowers. What links them to each

other is a tendril, a fragile line of paint, a word.

She smirks. Good-bye on fire

See how she—

Fetus *V viva*

*Viva la vida* she writes in red with only one week left to live. Amputated leg and life. The grave we dig all night.

Dress on fire halo tendril.

Toward the end of June when her health improves she will ask, *What are you going to give me now as a prize since I'm getting better? I'd like a doll best*

The strange dancing legs.

*I would like a doll most.*

She covers her wooden leg with boots made of red leather with Chinese gold emblazoned and bells embroidered. And she dances. But only once. Heartbroken. *Love me.* How badly tonight.

Life—begging for it by then, remembering she smiles— she'll be begging for it by then. Not yet.

A perfect day: make love, take a bath, make love again.

And sucking drugs and roses. *If you could feel what I feel.*
And she carves a door. The drone of the box and the cross and
the word.

*love, love.*

In another garden altogether

force-feeding you the end

Knife through the succulent melon—knife through. All the
weeping fruit. She whispers bites my ear but gently blurs,
seduction, love, *no blood,* she whispers, biting—*Shh—Shh—or
they'll hear—*

Men ascend with dirges but.

With Glory Bes to the Father and to the Son but.

Ascend with testimonies, reviews, dirges, posthumous ap-
praisals but you refuse. *"While other artists of her generation
(Rivera included) were trying to master the tilting planes of Cubism,
Kahlo was painting herself flat on her back, having a miscarriage—
and recycling her sorrows as spectacle."* With double recrimina-
tions, but you refuse. Carrying the wooden box.

Falling off that ludicrous pedestal. The plaster cracking.
Your corset. Breaking into arms and legs. Dance away. Resilient
one. Trying to keep up. A three-legged race.

Men ascend with passions, compliments flirtatious but—

You are driving in a Lincoln Continental convertible with
Doctor Polo. Jangling. Charms. You ask for a double tequila.

Caught in the buzz and hum

the festival of the sun.

*Beauty is convulsive or not at all.*

I love you Frida next to the next to the painting sound, the
scraping sound *don't go.*

I love you next to the solitude.

Her increasingly dark and silent theater, her darkening ve-
randah of invitations, talons, treacherous birds, monkey, song-
book, her wrought-iron

Men ascend *look:*

A love-lorn woman with a cup of poison fallen dead at her

blue door

Cupped, her hands reveal a little bird, a box, solace, a 3 7 9

Her very blue door, then door of earth, you wave the fetus

cackle babble drugged: abyss oblivion sorrow

*Papá!*

You see birds, the planets you see a little deer and you see

your father closing the aperture now.

hourglass

pyramid

a deer with 9 arrows—confined to an apparatus

In Aztec mythology and iconography the image of the deer

stands for the right foot.

*Crimson*

*Crimson*

*Crimson*

*Crimson like the blood*

*that runs*

*when they kill*

*a deer*

The names in pink on her bedroom door:

*Maria Félix*

*Elena Vásquez Gómez*

*Marcela Armida*

*Irene Bohus*

*Maria Félix* you cry!

*Viva la vida* she scrawls on my breasts. And I am trying to extricate myself—in anticipation of the end.

*Coward,* she hisses.

*Viva la vida.*

Her ruined leg.

*Oh Valentin, Valentina,* she croons

*I too know how to die. But if*

*they're going to kill me*

*tomorrow, why don't they*

*kill me now?*

    Hair on fire wayward halo angel garden fur and there yes

good no yes oh paint no scrape it hurts like that right there—

opening—to reveal 9 arrows—sorrow, nails and roses, upside

down, now up, now down, hold there, oh look—oh love—

*Comb my hair Cristina*

*Arrange my hair with combs now*

*Color of poison*

*Everything upside down.*

*Me? Sun*

*and moon*

*feet*

*and*

*Frida*

Heartbroken

She pictures the V

a little

free

Viva

Holding a melon on the eve of her death

Trying to let go of—

3          7          9

tenacity and wildness

of the day

of the night

*A perfect day: make love, take a bath, make love again.*

And we force feed her tubers and the end.

Men ascend with the pine box looking for your body but

She closes her eyes recalling her twin votives: vision, devotion

She would become happy in front of any beautiful thing.

She clutches a tequila and a sugar skull. Against the blue door
she poses a moment longer. Then she walks one-footed down
the hall, poor paw, poor paw

and she says *live* once more, and she says *love*

arranges the fruit: watermelon on the dark earth
once more
the ripe red
*love, love*
*Viva la vida*

And she picks up a brush.

# Incessant dreaming: Chalice

*To love you very much with an M*
*as in music or mundo.*

All the things you held and hold . . .

and everything and everyone you loved

and all you wanted feared and—

your jokes:

Frida clung to her sense of the ridiculous; she loved to play,

and on days when her natural exuberance won out against

pain, she created a stage from the semi-circular metal contrap-

tion designed to keep her right leg raised, and produced pup-

pet shows with her feet. When the bone bank sent a bone ex-

tracted from a cadaver in a jar labeled with the name of the

donor, Francisco Villa, Frida felt as vital and as rebellious as

her revolutionary bandit hero Pancho Villa. With my new

bone, she cried, I feel like shooting my way out of this hospital

and starting my own revolution.

your disdain  your rage

absurdity of the maimed and desperately decorated

your handful of black charms suns moons and stars

your handful now of nights and days left

your Diego votives: *venga*

Without flinching you hold your pain  that cup of mysterious

universe

your *viva la vida*

your joie de vivre

And you make love freely to the world—burning

gracious, overflowing  wayward halo cup on fire

And you play the *jeux de la vérité* in Paris, the game of truth

and when you refuse to tell your age your punishment is to

make love to the chair—which you do—beautifully.

laughing lovely chalice.

The project was conceived and executed in the spirit of fun.
No one presumed that a great work of art would be produced.
The style combined the broad, simplified realism of Rivera with
the awkward primitivism of the *pulquería* mural tradition. The
subjects—town and country scenes based on the bar's name (The
Little Rose) and the theme of pulque—were delegated according
to each student's predilection. Fanny Rabel recalls that her job
was to paint a little girl. She also put roses in the pasture.

All you held, and gently:

Her students agree that Frida's teaching was completely unpro-
grammatic. She did not impose her ideas on them; rather she
let their talents develop according to their temperaments and
taught them to be self-critical. Her remarks were penetrating,
but never unkind.

balancing hope, exchanging fires

All you saw:

drawn to the vision, dreaming one:

a purple carnation

a red ribbon in her hair

her lips are crimson

eyebrows like swallows

monkey, skeleton, exposed heart, a blood-red ribbon

a paw

at the fetish altar

flower of life

shells symbols of birth, fecundity,

a scallop and a conch intertwined by the roots

from the magenta frame flowers, fruit, Frida, a red vein

She would become happy in front of any beautiful thing

Fanny Rabel: Frida's great teaching was to see through artist's

eyes. . . . She did not influence us through her way of painting,

but through her way of living, of looking at the world and at people and at art. She made us feel and understand a certain kind of beauty in Mexico that we would not have realized ourselves. . . . She did not impose anything. Frida would say, Paint what you see, what you want. We all painted differently. Followed our own routes. We did not paint like her. There was lots of chatting, jokes, conviviality. She was not giving us a lesson. Diego, on the other hand, could make a theory about anything in a minute. But she was instinctive, spontaneous. She would become happy in front of any beautiful thing.

Delirious chalice:

She took huge doses and mixed them in the most unorthodox ways. Several times when Raquel Tibol was helping Cristina care for Frida she watched her put three or more doses of Demerol into a large syringe and add various small vials of other narcotics.

Without flinching you hold and are held by pain:

Ella Paresce, an American pianist who visited Frida often, remembered how one cast almost killed her. Frida had allowed a friend who happened to be a doctor, but with little experience in applying casts, to put a plaster corset on her one afternoon while friends were over. Everyone watched and laughed along with Frida as he molded it to her body.

Then during the night, Ella explained, the corset began to harden, as it was supposed to do. I happened to be spending the night there in the next room, and about half past four or five in the morning, I heard a crying, nearly shrieks. I jumped out of bed and went in, and there was Frida saying she couldn't breathe! She couldn't breathe!

The corset had hardened, but it hardened so much that it pressed on her lungs. It made pleats all around her body. So I tried to get a doctor. Nobody would pay any attention at that hour in the morning, so finally I took a razor blade and knelt on the bed over Frida. I began slowly, slowly cutting that corset right over her breast. I made about a two-inch cut so that she

could breathe, and then we waited until a doctor appeared, and he did the rest. Afterward we laughed to tears over this thing. Frida's hospital room was always full of visitors. Dr. Velasco y Polo recalls her fear of solitude and boredom. What she liked was gaiety, spicy gossip, and dirty jokes. Volatile by habit, she would, says the doctor, get very excited and say, "Listen to that son of a bitch, please throw him out of here. Send him to the devil." When she saw me with a pretty girl, she'd cry, "Lend her to me! I'll smoke that one myself!" She liked to talk about medicine, politics, her father, Diego, sex, free love, the evils of Catholicism.

Trotsky, Noguchi, Muray, floating in the extraordinary cup of her. Her trinkets, treasures. Her assortment of lovers.

My adorable Nick—

I am sending you from here millions of kisses for your beautiful neck to make it feel better. All my tenderness and all

my caresses to your body, from your head to your feet. Every inch of it I kiss from the distance.

*To love you very much with an M as in music or mundo or Mexico:*

I remember that I was four years old when the "tragic ten days" took place. I witnessed with my own eyes Zapata's peasants battle against the Carrancistas. My situation was very clear. My mother opened the windows on Allende Street. She gave access to the Zapatistas, seeing to it that the wounded and hungry jumped from the windows of my house into the "living room." She cured them and gave them thick tortillas, the only food that could be obtained in Coyoacán in those days.

Your eyes—grave chalice—all you held and hold
Beautiful witness
Cherish.

And you hold good-bye and tenderly now:

*Since you wrote to me, on that day so clear and so far away, I have*

*wanted to explain to you, that I cannot escape the days, nor return*

*in time to the other time. I have not forgotten you—the nights are*

*long and difficult. The water. The boat and the pier and the depar-*

*ture, that was making you so small, to my eyes, imprisoned in that*

*round window, that you looked at in order to keep you in my heart.*

*All this is intact. Later came the days, new days of you. Today I*

*would like my sun to touch you.*

*The huipil with reddish-purple ribbons is yours. Mine the old*

*plazas of your Paris, above all the marvelous Place des Vosges, so for-*

*gotten and firm. The snails and the bride doll are yours too, that is to*

*say you are you. Her dress is the same one that she did not want to*

*take off on the day of the wedding with no one, when we found her al-*

*most asleep on the dirty floor of a street. My skirts with ruffles of lace,*

*and the old blouse . . . make the absent portrait of only one person.*

*But the color of your skin, of your eyes and your hair changes with the*

*wind of Mexico. You also know that everything that my eyes see and everything that I touch with my own self, from all the distances, is Diego. The caress of cloth, the color of color, the wires, the nerves, the pencils, sheets of paper, dust, cells, war and the sun, all that lives in the minutes of the no-clocks and the no-calendars and the no-empty glances, is him—You felt it, for that reason you allowed the boat to carry me from Le Havre, where you never said good-bye to me.*

*I will always continue writing to you with my eyes. Kiss the little girl.*

I started painting twelve years ago while I was recovering from a bus accident that kept me in bed for nearly a year. In all these years, I've worked with the spontaneous impulse of my feeling. I've never followed any school or anybody's influence; I have never expected anything from my work but the satisfaction I got from it by the very fact of painting and saying what I couldn't say otherwise.

*I have made portraits, figure compositions, also paintings in which the landscape and still lives are the most important. In painting I found a means to personal expression, without any prejudice forcing me to do it. For ten years my work consisted of eliminating everything that didn't spring from the internal lyric motivations that impelled me to paint.*

*Since then my themes have always been my sensations, my states of mind, and the deep reactions that life has been causing inside me. I've frequently materialized all that into portraits of myself, which were the most sincere and real thing that I could do to express how I felt about myself and what was in front of me.*

Once when a gardener brought her an old

chair, asking if he should throw it away, she

requested him to give her the broken leg, and

she carved her own lips on it to make a gift for

a man she loved.

# Kiss the Little Girl

She draws. She draws a door of breath. Breathes on the pane
and dreams. She walks once more. Six years old. To the river of
glass. *Papá*. Just a child. She smiles. All is.

All is . . .

Here is a kiss

Night is falling

Night is falling in my life

Sleep

Sleep

I'm falling asleep

Darling Papá

I send you all my affection and a thousand kisses. Your

daughter who

adores you

Frieducha  here is a kiss

Write to me

everything you do

and everything that happens to you . . .

And she sings, *Don't let your eyes cry when I say good-bye.* And

she crows and cries *good-bye.*

Your dress may hang there, but you are already elsewhere.

without flinching

Your dress hangs there but you are

In June she asked that her four-poster bed be moved from the small corner of the bedroom out into the adjacent passageway which led to her studio. She wished she said to be able to see more greenery. . . .

She draws an O on the windowpane in breath.

The girls liked to loiter—in the court of miracles. She dreams

Here is a kiss.

Her wayward halo—all the mutilated beauty.

Toward the end of her life Frida described the series of orthopedic corsets she wore after 1944 and the treatments that went with them as "punishment."

There were twenty-eight corsets in all—one made of steel, three of leather, and the rest of plaster. One in particular, she said, allowed her neither to sit nor to recline. It made her so angry that she took it off, and used a sash to tie her torso to the back of a chair in order to support her spine. There was a time when she spent three months in a nearly vertical position with sacks of sand attached to her feet to straighten out her spinal column. Another time Adelina Zendejas, visiting her in the hospital after an operation, found her hanging from steel rings with her feet just able to touch the ground. Her easel was in front of her. We were horrified, Zendejas recalls. She was painting and telling jokes and funny stories.

The vials of Demerol and other drugs all mixed up where tied to a wheelchair she worked for as long as she could and then continued in bed.

Mariana Morilla Safa remembers: In her last days she was lying down, unable to move. She was all eyes.

everything backward

sun and moon, feet and Frida

the amputated leg.

But after three months, she did learn to walk a short distance, and
slowly her spirits rose, especially after she started to paint again.
To hide the leg, she had boots made of luxurious red leather with
Chinese gold-embroidered trim adorned with little bells. With
these boots Frida said she would "dance her joy." And she twirled
in front of friends to show off her new freedom of movement. The
writer Carlota Tibon recalls that Frida was very proud of her little
red boots. Once I took Emilio Pucci's sister to see Frida, who was
all dressed up as a Tehuana and probably drugged. Frida said,
these marvelous legs! And how well they work for me! and she
danced the *jarabe tapatío* with her wooden leg.

Please don't leave me immediately when I fall asleep. I need
you nearby, and I feel it even after I am asleep, so don't go away
immediately.

And from deepest sleep she begs still *not the not the* . . .

*not the leg* . . .

So I always lay down beside her and she called me her little
prop. And sometimes I sang to her. . . . And she'd ask me for
another cigarette. And when she was nearly asleep I'd ask if I
should take it and she'd smile no, not yet.

> *I kiss you through the distance.*

> For Frida Kahlo in her convalescence—
> Beauty is Convulsive
> these tendrils of ink from me to you

I kiss you through the distance

This small court of miracles

A sea of votives floating on the river: *courage*

I am happy as long as I can paint. Not yet.

Is that you? Just a girl at the Preparatoria—and then—

She cries for the wet nurse

*kiss the little girl*

The brown bloom of her

suck and want

mouthing

love

holding

light

good-bye.

*It is coming. my hand. my red*

*vision. larger. more his.*

*martyrdom of glass. the great*

*nonsense. Columns and valleys.*

*fingers of the wind. the bleeding*

*children. the mica micron.*

*I don't know what my mocking*

*dream thinks. The ink, the stain.*

*the shape. the color. I'm a*

*bird. I'm everything. without any more*

*confusion. All the bells.*

*the rules. the lands. the*

*big grove, the greatest*

*tenderness. the immense tide.*

*garbage. water jar, cardboard*

*cards. dice digits duets*

*vain hope of con-*

*structing the cloths, the kings.*

*silly. my nails. the*

*thread and the hair . . .*

# *Adios*

*What is it Diego?*

*It is just that we are not very sure that she is dead.*

*She is dead, Diego.*

*No but it horrifies me to think that she still has capillary action. The hairs on her skin still stand up.*

*I assure you she is dead.*

Olga Campos was among the early mourners: It was terrible for me. Frida was still warm when I arrived at the house around ten or eleven in the morning. She got goose pimples when I kissed her, and I started screaming, She's alive! She's alive! But she was dead.

*But it horrifies me we should bury her in that condition.*

*It's very simple, Diego. Let the doctor open her veins. If the blood doesn't flow she is dead.*

Rosa Castro: When Frida died he looked like a soul cut in two.

At a quarter past one, Rivera and various family members lifted Frida out of the coffin and laid her on the automatic cart that would carry her along the iron trucks to the crematory oven.

accompanied by music:

*I'm off now to the port where the golden ships lie*

Everyone was hanging on to Frida's hands when the cart began to pull her body toward the oven's entrance. They threw themselves on top of her, and yanked her fingers in order to take off her rings, because they wanted something that belonged to her.

151

*Stay*

At the moment when Frida entered the furnace, the intense heat made her sit up, and her blazing hair stood out from her face in an aureole.

The fires in the old-fashioned crematorium took four hours to do their job.

Her ashes retained the shape of her skeleton for a few minutes before being dispersed by currents of air. When Rivera saw this, he slowly lowered his clenched fist and reached into the right-hand pocket of his jacket to take out a small sketchbook. With his face completely absorbed in what he was doing, he drew Frida's silvery skeleton. Then he fondly gathered up her ashes in a red cloth, and put them in a cedar box.

In the incineration she sits upright
At the furnace door forced by heat.

Her hair on fire like a halo

*Love, I am the disintegration*

She smirks good-bye she laughs she waves on fire

*Love, I am.*

*Thanks to the doctors*
*Farill—Glusker—Parres*
*and Doctor Enrique Palomera*
*Sánchez Palomera*
*Thanks to the nurses*
*to the stretcher-bearers to the*
*cleaning women and attendants at the*
*British Hospital—*
*Thanks to Doctor Vargas*
*to Navarro to Dr. Polo*
*and to my will-*
*power*
*I hope the*
*leaving is joyful—and I hope*
*never to return—*

                        *FRIDA*

And she leaves the frame

*You must have been an angel,* he mutters from the height

Heat and light

And he takes out a crumpled piece of paper
and draws her skeleton of ash—before it crumbles
*heart, heart*

Not long after Frida died, Rivera's granddaughter was baptized
in the Coyoacán house. For the occasion, Diego dressed up a
Judas figure, perhaps a skeleton, in Frida's clothes, and a bag
containing her ashes and her plaster corset was laid in a cradle.

Her ashes in a sack on top a plaster death mask and a *rebozo*
wrapped, O Frida, Diego whispers, you are beautiful like that.

In the Frida Kahlo Museum beneath a protective glass ball is an
assemblage of small objects—an equestrian cowboy on top of a
skull, tin soldiers, dice, toy angels, all on pedestals. . . . A piece
that was surely hers, a gift for Alejandro Gómez Arias, was a
world globe that Frida covered with butterflies and flowers. In
a later year when she was sick and unhappy, she asked for it
back and covered the butterflies and flowers with red paint. . . .

*no moon, sun, diamond, hands—*
*fingertip, dot, ray, gauze, sea.*
*pine green, pink glass, eye,*
*mine, eraser, mud, mother, I am coming.*
*=yellow love, fingers, useful*
*child, flower, wish, artifice, resin.*
*pasture, bismuth, saint, soup tureen.*
*segment, year, tin, another foal.*
*point, machine, stream, I am.*

*To love you very much with an M as in mundo or music.*

Look at her work . . . ascetic and tender, hard as steel and fire

and delicate as a butterfly's wing, adorable as a beautiful smile

and profound and cruel as life's bitterness.

*Diego, Diego*

We are held together by smoke now

I know the way.

# World Tonight

You are walking down a dirt road alone—free for a moment
from the sorrow and drama of your life, free of your body's pain—
free of—free. . . .

You are walking without physical pain for a moment
though it informs each step. Drawn to the swirling. A little free,
a little free of—dragging a right foot.

While you have not forgotten it, for a moment, sucking on
a paintbrush and looking up into the fiesta of the sun you see
yourself walk away—walk out—out of your leather corset, your
steel corset, your plaster corset, your corset of thorns and tears.
Your abyss of dark birds. *Diego, Diego.*

*I am sweeping the earth. I am soaking the earth with my tears.*
Dragging a right foot. Sorrow.

Brushing up, rubbing up slightly against her—*I am sweep-
ing the earth with my hair, with my grief.*

All is failed—but the light is not failed. Walking away from your marriage which seems to be failing for a second time. One good leg.

You take her hand. She pulls on your necklace of swallows and thorns. You take her to the ditch at the end of the dirt road. You chew the earth at her door, screaming for her to come with you—down the dirt road—home. You take her hand and pull her with you, free. A little free. Free of—

You have come to the place of utter sorrow and coast as the end approaches. Smoke rising from the river.

As the end nears. You cradle a sugar skull.

And the small boats put up their white sails and your workers of the world unite once more. . . . See how the shoreline recedes and the boats and the dirt road you loved and walked no. And the roses. You are dragging her here to this—and your country soaked in blood and broken. Yes, you whirl in your communista, raising a fist and cigarette and swagger. Mouthing Trotsky, all your thorns and roses. Your country, body gone to blood and broken. And you charm her with your

fetish and image and promises and she watches as you suck on the edge of your corset. You swear into her ear as you lower her. You bisect in every possible way her body, in the ditch, laughing maniacally, left for dead, on the dirt road

home—

Without pain.

In pain in dread—you are devouring time and the earth and the woman—you are devouring women—in your bravado—

And the woman mud smeared all over her breathless points and gasps at the little deer pierced by arrows.

Laugh and cuss scrawl on her body with earth and blood you whisper: *I hope the exit is joyful. And I hope never to come back.*

hourglass

Because I am running out of legs, life.

Free. Free of.

She offers her palette like a heart. Paints fertile earth: green vines and leaves spring from her womb, her heart, while blood drips into veins that take root in the soil in front of her.

She nourishes the earth with her body, the woman with her body. She feeds the earth

fecund one. darling earthling.

soil, love.

She holds herself above her—lowers herself feeding folds and folds of fertile, gorgeous earth.

She smiles. *You are sweet. And Diego too would like you.* And she drags her down—rooted to the soil

stone spine

vagina fused to the throbbing earth

sunken

fucked.

The feminine earth. Lit by roses. Body of a woman, fire, future in your darkening theater. Proscenium of night. And you smile, mutter, not in any known language *I am eating the earth. I need the earth in my mouth now.* A rose opening. *Chueca.* Perfect one, unbroken.

*Put it into my mouth now.*

A tree grows inside you. I have seen it. Leaves sprout from your veins. Your blood nourishes the earth.

You drag your sexual entrails to this sacred place—drawn to the swirling—this final place of fury, desire—your tears are nails and paint—abyss of birds—ruined spine, leg.

No

No

Blood shall be shed.

One good leg

*Kiss me. Again.*

And she is furious, a fury flailing, screaming. Tortured— then replenished.

Hung upside down, naked, tied in an attempt to strengthen her spine.

And you are left in the end with all that pain cannot take from you.

Many nights she hung upside down from the bed's canopy. The blood rushing to her head. While the women sat and whispered, prayed.

Pray:

*Come to me now, down the dirt road, my little one—you re-
mind me of a little girl I once knew at the Prepa (smooth and per-
fect) —before the accident.*

And you sit laughing with all that pain cannot take.

And who could refuse you? Your dark dares　ˏ

your outrageous, your flagrant

your stare

*If I could carve with thorns Diego into you allegiance. Fidelity.
Carve wild fidelity—my blood sport, my art—paint pulsing, paint
flowing—beauty—beating like an injured thing. If I could carve my
pain. Draw blood.*

Look you say pointing to the little deer pierced by arrows.
Its head of a saint. Its head of a cursing martyr. Its leather
corset. A grief-induced hallucination. A sex-induced or pain-in-
duced—*Look there:* the open fruit. The lacerated melons, pome-
granates revealing their juices, juicy—just a little skin pulled
back on that one. Pulpy, hurt and splayed.

She is arranging and rearranging her long black hair and earth. The trinkets in her hair. The arrangement on the dressing table. She looks at the woman in the mirror. Slowly applies paint. Radiant, radiate. Free. She stares and offers her the heart-shaped palette:

World tonight.

Men ascend double staircases looking for you.

But you are not there.

You are out painting. You are watching the eclipse. You are balancing fire. Arranging and rearranging. Outlining the shape of a woman and gently filling her in.

You are nailed by roses now and gently fastened by the girl to this extraordinary world.

You are in the midnight garden spooning earth,

devouring gorgeousness.

*because I miss you with all my heart and my blood, Diego.*

heart and blood solemn

feed me slowly tonight

filling my mouth

All the distance, earth diminishes between us

A door.

And she falls into dream. And in the dream she is free from her pain a little, though it is never far off—and she is walking down a dirt road.

And she is sucking the blood from her brushes, free. And she is looking in the mirror and she is painting the earth and she is sucking on the earth. And she stops to bring Diego his lunch and the white woman with the pen says, and the gringa yells Frida leave that fat man for awhile! And the gringa is sucking on a pen and writing this: You are walking—a dirt road—free of pain.

*Easy for you to say, chueca. Easy for you . . . With your pale pornography of hope, your "dirt road alone," your pretty ink-stained hands, your little poems in prose, your mouth, your thigh. A rage of perfect white.*

I am touching the tip of your cervix—which is the earth. A plum. I am sifting, gorging, adoring your earth. As you paint your pain. Your lamentations, your incantations, your seductions in paint.

*What do you know of pain?* she asks. Biting into my neck.

Forcing me into her burning, thorned corner. Torched: *if you*

*could feel what I feel* . . . And we hold the pose.

Leather corsets. Plaster corsets. Steel. Let us descend into

perfect earth, black earth, fertile, free. Carving roses. Put your

hands all over me. Replenishing and torture. I penetrate the

sex of the whole earth. Your brown, round, your dark ten-

drils, arrogant, gorgeous, bejeweled. Light. Bride tonight. And

I am holding your furious world tonight. *It's so hard to let go,*

she says. I am holding the broken terra-cotta of your body at

last. Don't go. You laugh. A sugar skull dissolving. A rose be-

neath your tongue. And the world turns magenta as you come

and we dream for a moment of something whole, no blood.

No blood.

No blood.

children of poverty.

No blood.

hurt of the earth

No blood.

all the assassinated friends

*votive: devotion*

Light tonight.

And she remembers—just a girl—opening

She draws a door. And her death opens. All is

River of light. And her father photographs her. . . . River

of—sublime tonight.

She loves the sun clanging and she's drawn.

Child tonight.

Lighting a small votive, she watches it float out on the river.

River of—

Smooth and perfect thigh tonight.

A furred thing in the dark—stars . . . A rubbing all over
with earth and leaves. Furred lip of the open fruit. She reaches
for her palette. The way color. *Let me live,* she begs. In pain and
dread she is desiring, devouring time and—

There's a fire in the earth where you lay.

*Swear my linda, swear. My juiced up plum, plump . . . my little*

*goose—my gringa. Swear you will—swear:* And she is drawing all

the fruits of this world.

Hurt of the earth convulsive beauty bride tonight. Free.

Free of—

that odd exaggerated step.

No blood

No blood

And pain is a rose beneath your tongue dissolving.

And pain is just another way there.

You walk. The road of tears is broken. So love me again un-

til we're left for dead. Exhausted, unmoving, bereft. She opens

one eye and laughs like a wild thing. Bats her lashes. Takes the

little spoon from around her neck and feeds me earth. She

writes *Diego, my love* all over my body in mud. Mischievous one.

She writes *Viva. Viva la vida*

You write Diego all over my body. And as night approaches

you write *luz,* you paint light in fury. And she is devouring

everything, everything with her eyes. *I beg of you* she whispers.

*If you want me to go, take my sight*

Once again desire has made a ruin of us. A pile of loamy soil—a dome; or concave—a grave. And sweet pain is a tablet in your hand dissolving, a host beneath your tongue. A sugary skull. A rose. Where does your life go?

No

No

No blood

No blood

No blood      shall be shed

No blood      shall be shed

You are walking down a dirt road your people, body broken.

No blood      free for a moment

             a little free.

No blood shall be shed

She presses me up against an earthen wall.

World tonight.

Blind tonight.

Smooth and perfect—you are walking. . . .

Knife through the succulent melon knife through—

She closes her eyes and touches my unbroken body, my smooth and perfect thigh. She trembles, whispers, bites my ear but gently, blurs. *Take me to the other side.*

And the workers singing working songs.

And the women singing freedom songs.

And a woman outlining an image of herself with extreme care, tenderness, and filling it in.

No blood shall be shed.

No blood shall be shed

*Love me gently this time.*

No blood shall be shed anywhere in the world tonight.

# Author's Note

*Beauty is Convulsive* began after reading the extraordinary diary Frida Kahlo kept at the end of her life. I was struck not only by her last images, but by the power of her language: hallucinatory, dream-ridden, desperate, tender, written at her most vulnerable and open and perhaps most furious. I wanted in some way to be close to it—that trembling, defiant, beautiful, vibrant, wholly living page. I have tried to write a work of intimacies mingling the voices of Frida: the Frida of the diary, the Frida in her letters, in her Guggenheim application, with those who loved her and those who disdained her, with the doctors who cared for her—and, of course, her biographer. *Beauty is Convulsive* is utterly reliant of Hayden Herrera's *Frida*. How moving is her careful, judicious eye, the language of her attention, the sense that she too is changed in the end by her subject in that stunning act of retrieval—this voice became an essential one. I see *Beauty* as a book of devotions. At its heart is Frida's devotion to the image, to the vision, to the broken self, and to the dream despite everything to be free.

As my own words and concerns intertwined with hers, the book also became a deeply personal meditation: an attempt to be in some kind of dialog with her across time and space—and with myself. The desire was for the distance and earth to diminish between us. I experience *Beauty* not so much as a book but as a communion. And it did feel that way at times, through the miraculous months of writing—it did feel something like being alive together, for a little while.